ECHOES OF THE
DREAMTIME

ECHOES OF THE DREAMTIME

AUSTRALIAN ABORIGINAL MYTHS
IN THE PAINTINGS OF
AINSLIE ROBERTS

TEXT BY MELVA JEAN ROBERTS
INTRODUCTION BY DALE ROBERTS

J.M. DENT PTY LIMITED
Melbourne

THE DREAMTIME SERIES

The Dreamtime (Rigby, 1965) reprinted eighteen times
The Dawn of Time (Rigby, 1969) reprinted fifteen times
The First Sunrise (Rigby, 1971) reprinted eleven times
The Dreamtime Book (Rigby, 1973) reprinted eleven times
Dreamtime Heritage (Rigby, 1975) reprinted six times
Dreamtime: The Aboriginal Heritage (Rigby, 1981) reprinted four times
Dreamtime Stories for Children (Rigby, 1983) reprinted three times
Echoes of the Dreamtime (Dent, 1988)
Ainslie Roberts and the Dreamtime (Dent, 1988)

First published in 1988 by
J. M. Dent Pty Limited
112 Lewis Rd, Knoxfield 3180, Victoria, Australia
© All paintings and drawings: Ainslie Roberts
 1965, 1969, 1971, 1973, 1975, 1981, 1983, 1988
© Text: Melva Jean Roberts, Bessie I. Mountford
 and Dale Roberts

All rights reserved. No part of this publication may be reproduced, stored in a retrieval system, or transmitted in any form or by any means, electronic, mechanical, photocopying, recording or otherwise, without prior permission of the publisher.

National Library of Australia
Cataloguing-in-Publication entry:

Roberts, Ainslie, 1911– .
 Echoes of the dreamtime: Australian Aboriginal myths in the paintings of Ainslie Roberts.

 Bibliography.
 ISBN 0 86770 064 5.

 1. Roberts, Ainslie, 1911– . [2]. Aborigines, Australian—Legends—Pictorial works. [3]. Aborigines, Australian—Legends. I. Roberts, Melva Jean. II. Title.

759.994

Designed by Ainslie Roberts
Produced by Island Graphics Pty Ltd, Victoria
Typeset in 14-point Bembo by Solo Typesetting, South Australia
Colour reproduction by South Sea International Press, Hong Kong
Printed in Hong Kong

TO THE ABORIGINAL PEOPLE
who handed down these Dreamtime myths

CONTENTS

7	Introduction: Echoes of the Dreamtime
10	The Creator Kala and her Three Children
12	Birthplace of the Moons
14	Baracuma's Fishing Net
16	Banishment of the Goanna
18	The Rain-makers
20	The Blessing of Fire
22	The Sudden Darkness of the Ningauis
24	The Capture of the First Fire
26	Laughter at Dawn
28	The Gymea
30	The First Death
32	The First Kangaroo
34	The Bonefish Tree
36	The Kosciusko Bogong Moth
38	Waratah and the Blind Hunter
40	Kala Creates the Sea
42	Mopaditi and Cockatoos
44	Man of Magic
46	The Transformation of Burnba
48	The Parrotfish Rock
50	Garkain and the Trespasser
52	The Drought-breaker
54	Birth of the Butterflies
56	Yulu's Charcoal
58	The Scorching of the Birds
60	Mangowa and the Round Lakes
62	Milapukala, the Cockatoo-woman
64	The Mark of Wala-undayua
66	Creation of the Milky Way
68	Birth of the Seals
70	The Eagle and the Dingo
72	Creation of the Coorong Birds
74	Linga of Ayers Rock
76	The First Dawn
78	Jirakupai and Herons
80	Creation of the Jenolan Caves
82	The Last Hurricane
84	The Weeping Opal
86	Abduction of the White Swans
88	Goolagaya and the White Dingo
90	Koolulla and the Two Sisters
92	The Search for Moodai
94	Witana's Ochre Mines
96	The Desert Ice-men
98	The Trees Born of Fire
100	Wuriu Returns to the East
102	The Origin of the Platypus
104	Creation of the Inman River
106	Tirlta and the Flowers of Blood
108	Death of the Moon-woman
110	The First Birth
112	Black Pelicans and the Outcast
114	The Guardian of Owl Rock
116	Dingo and the Law-breaker
118	Wyungare and the Avenging Fire
120	Heritage of the Black Swans
122	Birth of an Ice-maiden
124	The First Fire
126	The Fire Tree
128	Jarapa and the Man of Wood
130	Songman and the Two Suns
132	The Call of Tukimbini
134	The Spirit Dingo of Ayers Rock
136	The Fighting Brothers
138	The Drought-maker
140	Wungala and the Evil-Big-Eyed-One
142	Wuluwait, Boatman of the Dead
144	Acknowledgements and Sources

'In the Beginning' 68 x 91 cm Mr and Mrs Robert E. Bond

ECHOES OF THE DREAMTIME

'In the beginning, God created the heaven and the earth. And the earth was without form, and void; and darkness was upon the face of the deep.' (Genesis 1: 1–2)

The profound mystery of the creation of the universe has occupied the beliefs of the peoples of the world—peoples of all colours and cultures—since the beginning of time. These beliefs have moulded the philosophies and ways of life of those to whom they belong.

And so it is with the Australian Aborigines. Their mythology—the legends and stories of their Dreamtime—deals with the creation of their universe and the establishment of their code of behaviour. Just as the beliefs of the Christian, the Buddhist or the Muslim dictate a particular way of life, so, too, the beliefs of the Aborigines form the foundations of their social, secular and ceremonial life.

This book presents a selection of interpretations of those beliefs. For some four decades, Australian artist Ainslie Roberts has been deeply involved with Aboriginal culture, a culture he long ago recognized as rich and vital, deserving to be noticed, respected and explored. He has done just that. After many journeys to the Centre and the North of Australia in the 1950s and 1960s, he began to do what no other artist had ever done: paint not the landscape of the myth but the myth itself.

Of course, these are not Aboriginal paintings. In Ainslie Roberts's own words:

... the Aborigines' interpretation of their mythology has resulted in some of the finest abstract art in the world: bark paintings, cave paintings, weapon decoration, rock carvings. The Aborigines have done it so well and so completely that for a white man to attempt it would not only be presumptuous but an insult to the whole Aboriginal community. Therefore, I saw my role as a 'communicator' ... a white man painting in the white man's way and trying, visually, to show the white people of Australia that this fascinating land they live in has a rich and ancient cultural heritage that they should be aware of and respect.

Ainslie Roberts's paintings reproduced in this book vividly bring to life the myths of that culture. His interpretations visually bridge the gap between the two peoples of this land. He brings us to a closer understanding of the Dreamtime beliefs which are the basis of Aboriginal culture—beliefs which are not really so different from those of other religions.

Indeed, most of the great religions of the world share similar themes. In the beginning there was nothing—until a mysterious creator formed heaven and earth, the oceans, the land, the sky and all the creatures. The Aborigines believe this too. Their myths describe how, before creation, the earth had always existed as a large flat disc floating in space. Its uninhabited surface was a vast featureless plain extending unbroken to the horizon. No hills or watercourses broke its monotonous surface, no trees or grass clothed its nakedness, nor did the calls of birds or animals disturb the quiet. It was a dead dark silent world.

'And the earth was without form, and void . . .'

There are those who might argue that it is somehow sacrilegious to compare the enshrined lore of the great religions of Europe and Asia to that of the primitive nomads of Australia. The idea that anyone could truly believe in the Rainbow Serpent, the Great Snake who ascended into the skies, may seem ridiculous. Yet hundreds of millions of Christians find no difficulty in believing implicitly that a snake spoke to Eve, that the Red Sea parted for Moses, that angels spoke from the sky and that a dead man was resurrected and ascended into heaven. These and similar miracles are the pillars of the Christian faith. So, too, are the Dreamtime creation myths the foundation-stone of Aboriginal culture.

Perhaps the important thing is not *what* a given culture believes, but rather that there exists in mankind the need to believe in *something*: that out of the struggling mystery of life, man should use the powers of the imagination to create guideposts by which his spiritual life can find direction. This is exactly what the Aborigines did in their Dreamtime stories; and Ainslie Roberts's creative imagination enables us to share in them. Since his work began to appear in the early 1960s, it has attracted an immense

public. Not only has he become one of Australia's most popular painters, but the readership of the Dreamtime books may be numbered in millions.

Many of the Aboriginal stories interpreted here, like those of the Old Testament, are moral parables that deal with the baser emotions of man—jealousy, hatred, envy and lust.

'... Cain rose up against Abel his brother and slew him.'
(Genesis 5: 8)

The Biblical story of Cain and Abel stresses the fact that brothers do not necessarily love one another. The Aboriginal myth of 'The Fighting Brothers' (p. 136) echoes this theme. To take another example, one of the basic principles of all religions is that life does not cease after death. The Aboriginal myth 'Birth of the Butterflies' (p. 54), which tells how reincarnation was deduced from the metamorphosis of caterpillars into butterflies, beautifully describes this universal belief. There has always been a close link between religion and natural phenomena; the Christian festival of Easter, for instance, uses the ancient pagan symbol of the egg as a sign of rebirth. The Aboriginal Dreamtime myths are no different. They have their whole basis in the natural world.

Ainslie Roberts's paintings dramatically demonstrate the intense affinity of the Aborigines with their land. Many of the myths he has depicted are the simple stories of how things came to be as they are.

'... and it came to pass ...'

These myths explain the origin of every topographical feature, large and small, the creation of life in its many forms and the origin of the natural forces. 'The Creator Kala and her Three Children' (p. 10), the first mythological interpretation that Ainslie Roberts ever painted, begins the story. It continues with 'The First Dawn' (p. 76), which tells the tale of Mooramoora, the great spirit who made the sun, thus creating day and night.

'And God said, Let there be light: and there was light.'
(Genesis 1: 4)

Wind, thunder, rain and fire form the basis of many of the paintings, as in 'The Last Hurricane' (p. 82), 'The Drought-breaker' (p. 52), 'The Rain-makers' (p. 18) and 'The Capture of the First Fire' (p. 24). These and other myths describe how the creators of the long-distant past travelled across the vast emptiness of the land fashioning all the natural features—as in 'Creation of the Inman River' (p. 104), 'Linga of Ayers Rock' (p. 74) and 'Creation of the Jenolan Caves' (p. 80). The exploits of the Dreamtime heroes and villains influenced the shape of the rocks, the colours of the earth, the windings of watercourses; all these had specific reasons for being. The same applied to every living creature—birds, fish, mammals, insects, plants and reptiles.

'And out of the ground the Lord God formed every beast of the field and every fowl of the air.'
(Genesis 2: 19)

The myths provide the Aborigines with a logical explanation of the world in which they live. But the most important of all the creation stories are those which decree the rules of behaviour that must be obeyed by all to ensure the harmonious functioning of their society. And these laws, clearly outlined in the Dreamtime mythology, have been handed down by the Aboriginal storytellers for tens of thousands of years.

Ainslie Roberts is a storyteller too. His visual communication is dramatically real because he, like the Aborigines, is very much in touch with his land.

His family arrived in South Australia from England on a hot dusty March day in 1922. The contrast of the soft grey dampness he had left behind in London with the harsh arid conditions of the Australian bush made an enormous impact on the impressionable eleven-year-old. For him, it was the gateway to another world. In the years that followed, he absorbed the atmosphere of the landscape around the country town of Ardrossan on the edge of Gulf St Vincent—the warmth, the mallee scrub, the sea, the sun. On the farm where he lived he learnt to milk cows, cut wood, handle horses and make butter, cream, cheese and bread. He swam, hunted and fished along the golden shores of the land he rapidly came to love. It made an earth person of him. This sympathy with his adopted country echoes loudly in his paintings today.

In a similar way, the emotional impact of the Dreamtime myths on each and every Aborigine was immense. Their overall effect was one of complete security. A man knew, always and forever, his exact place in society and in his physical and spiritual world. As he grew from infancy to adolescence and passed through maturity into old age, he knew he would advance through the hierarchy of his tribe with rights that no-one questioned and obligations that were expected to be fulfilled. He belonged to a totem which dictated the woman he could marry, the creatures he could hunt and the ceremonies he should perform. He lived in a tribal area reserved for him: he would not leave it, or permit others to enter, without negotiations performed in accordance with ancient laws. And he knew that if he transgressed any of the laws of his community, punishment was inevitable.

'Behold, I set before you this day a blessing and a curse; a blessing if ye obey the commandments of the Lord your God . . . and a curse if ye will not obey . . .' (Deuteronomy 11: 26)

In all these circumstances, an Aborigine moved through life with the supreme confidence of a man who knows that he is surrounded by the spiritual beings who established his world. He could see constant proof of their existence. He saw their marks on the earth. He saw them in the form of plants and animals—as depicted by Ainslie Roberts in 'The Gymea' (p. 28) and 'The Eagle and the Dingo' (p. 70). He felt them in the changes of the seasons and watched them as they moved through the skies in the form of clouds, sun, moon, planets and stars. All of life was one and he was a part of life, bound immutably within the great design worked out for him by his creation ancestors.

It would be tempting to believe, too, that a design had been preordained for the life of Ainslie Roberts. His formative years in Australia were spent within easy reach of the bush and he began to express his early love for the land by drawing it. He drew naturally. It was not until his mid-teen years that he undertook any formal art training, attending night school at the South Australian School of Arts and Crafts. His fluent technical skills were then honed to perfection over the years through his career in commercial art in his own advertising agency. And his 'seeing eye' was further cultivated through his great interest in photography, an artform in which he gained international renown.

Then, in 1950, the pressures of executive life, for which he was not designed, took their toll. Dissatisfied, unfulfilled and suffering the tension of business claustrophobia, he collapsed mentally and physically. This resulted in an enforced period of recuperation in the isolation of Central Australia. And there he discovered his *raison d'être*. His early deep relationship with the land found an echo in the fellow-feeling of the Aborigines. He soon came to know them, and, stimulated by his friendship with ethnologist Charles Mountford, turned his back on his success in the business world and began to paint the myths of the Aborigines—perhaps the task that his 'creation ancestors' had ordained he perform.

'To everything there is a season, and a time to every purpose under the heaven: a time to be born, and a time to die.'
(Ecclesiastes 3: 1)

We have seen that Aboriginal mythology has a relationship to the mythologies of most other lands. Most employ similar plots and characters, and parallels are easy to draw. The story of unconsummated love, for example, is universal. In many Aboriginal tales, some tragic intervention prevents the two young lovers from coming together, and so their love is magically perpetuated by a natural feature. The Aborigines' explanation of 'The Origin of the Platypus' (p. 102) is a typical example.

The Greek and Roman myths, too, have heroes possessed of magical or superhuman powers. Many tales of Homer describe how the gods and demigods of Olympus created mountains, volcanoes and the eastern coastline of the Mediterranean. This is exemplified here in 'Kala Creates the Sea' (p. 40). The explanation of natural phenomena by mystical causes is common to legends of other countries. In the sagas of the Nordic races, the early gods made the complete universe—the earth, the sky, the seas and all the natural forces. Here, 'Mangowa and the Round Lakes' (p. 60) and 'Creation of the Milky Way' (p. 66) typify that theme.

Again, the complex spiritual culture of the Aboriginal Dreamtime mythology has an affinity with the mystical life of peoples in many other parts of the world. The echoes are obvious. It can even be argued that Aboriginal mythology derives not only from the Dreamtime of the Aborigines but from the Dreamtime of the human race as a whole. But despite their probable basis in an ancient spiritual brotherhood common to all humanity, the Australian Aboriginal myths are unique. Isolated for hundreds of centuries on a continent remote from the influences and intermixings of diverse societies, the Aboriginal beliefs have continued to be passed down in their elemental form, untinged and uncompounded by the sophistication of other hybrid cultures—simple, immaculate, pure. Stories that began in the Stone Age have survived unchanged.

A part of this incomparable heritage is offered to us through the paintings of Ainslie Roberts. Like the mythology he depicts, his creative mind strives to exclude influences other than those of the Australian Aborigines and their land. The interpretations he has given us are as full of imagery and fantasy as the myths on which they are based. They reveal both the sensitive creativity of the true artist and the fertile imagination of the Aboriginal storyteller. They are echoes of the Dreamtime.

DALE ROBERTS
Belair
South Australia

THE CREATOR KALA
AND HER THREE CHILDREN

Australia is an ancient land, undisturbed by any major geological upheavals for many millions of years. Its people, too, are an ancient people who, reaching the shores of this continent tens of thousands of years ago, were able to follow their simple way of life until we, the white intruders, came among them.

The myths of these ancient times were accepted as absolute truth and an answer to all the questions of living.

In the beginning, the earth was flat and featureless, unbroken by any mountain range, river or major natural feature. Nor was it inhabited by any living thing. A great darkness covered all space and this darkness was silent and still. In it the earth was mute. There was no sound of wind. Nothing moved.

Then, at some time in the long-distant past to which the Aborigines refer as the Dreamtime, giant beings wandered over the country. As they travelled, these Dreamtime heroes carried out the same tasks as do the Aborigines today. They camped, made fire, dug for water, fought each other and performed ceremonies.

For the Tiwis of Melville Island, the creation myth is that of Mudungkala. It relates how, suddenly, out of the darkness, came a great upheaval of rock and earth. The vast featureless face of the land moved and cracked as the landscape erupted with life and sound.

And out of the depths emerged an old blind woman, Mudungkala, clutching her three children, a son and two daughters, to her breast.

The journey of life had begun.

137 x 91 cm Mr K.G. and Mrs E.S. Brandt-Wilson

BIRTHPLACE OF THE MOONS

Aboriginal mythology records that in the earliest days of the Dreamtime the moon did not wax or wane but shone constantly as a full moon. This ended when the spirits, in punishment for its indiscretions, decreed that 'the Moon will no longer shine constantly, and each month must die for three days'.

A variation of the belief is this myth, which describes how full moons were born and how they waned.

There was a place known as the Valley of the Moons, where the soil was the richest on earth, and in it grew the Moons. When each Moon had grown large enough to leave the valley and venture up into the night sky, it would break free of its mother plant and float about in the valley until its turn came to take its place in the sky.

Like all growing things, the Moons needed the Sun in order to grow big and strong. But the Sun was really their enemy because it was jealous of anything that tried to share the sky with it.

So, when each Moon rose out of the valley each month, the Sun—huge, hot and powerful—would race across the sky in pursuit and reach out with its fiery fingers to tear pieces off the Moon until it was all gone.

The tiny pieces that broke free when this happened became the stars.

91 x 117 cm Mr Steve Carapetis

BARACUMA'S FISHING NET

In a myth from South Australia, Baracuma owned the only fishing net in the world. It was so good that when he cast it into the water the net immediately filled with fish. Wandi, a friend from a neighbouring tribe, heard the story of the wonderful net and begged Baracuma to allow him to use it.

Baracuma refused to lend the net, because he knew that if it was out of his possession for any length of time he would die. Wandi pleaded with Baracuma, assuring him that he would return the net promptly. Baracuma, persuaded against his better judgment, at last allowed Wandi to take the net away.

However, the fish were so plentiful that Wandi forgot his promise until darkness forced him to return the net. To his dismay, he found that Baracuma was dead. He tried all night to bring his friend back to life, but without success. Wandi was so ashamed over the result of his selfishness that he changed himself into a hawk and flew to the top of a high tree.

An old kangaroo-man heard that Baracuma had died for his generosity, and used magical powers to restore him to life in the form of a native cat.

The Aborigines believed that this is why Wandi the hawk lives and nests high in the treetops, and hunts for his food during the day, while Baracuma the native cat avoids the selfish Wandi by making his home underground and catching lizards and other small creatures during the hours of darkness.

Baracuma's Fishing Net

68 x 91 cm Mr and Mrs Norman Farrar

15

BANISHMENT OF THE GOANNA

There have always been mean and selfish people, even among the Aborigines who first lived in Australia. This myth relates how the selfish Goanna-men were outwitted by their wives, the Gecko-women.

During a great drought, the Goanna-men had a secret waterhole which they would share with no-one but their own tribe. But their wives, seeing so many others, young and old, dying of thirst, determined to find the waterhole in order that everyone could share it.

So the wives told their men that one of the women—who was actually hiding in the hills—had been stolen by a stranger. The Goanna-men immediately suspected the men of the neighbouring Emu tribe and set off to do battle with them.

With their men out of the way, the women began their search. They were aided in this by a magical stick given to one of them the previous night by her dead grandmother—for the dead sometimes help living relatives who are in serious trouble.

When they found the spring that fed the waterhole, the women drove the stick deep into the opening in the hillside. Immediately the water poured out in a torrent to form a huge river, and all the people from the tribes drank their fill of the sweet liquid.

The evil Goanna-men were enraged—they had lost not only their secret waterhole, but their power to hurt others. The Gecko-women climbed to the top of a large gumtree where, to escape their husbands' wrath, they changed themselves into the little gecko lizards that live under the bark of trees today.

For their sins, the spirits banished the men from the area, destined to live forever as goannas in the great red sandhills and the dry open plains.

This story was often told to Aboriginal children to teach them that water belongs to everybody, and that those who disobey this law must be punished.

91 x 122 cm *Private collection*

THE RAIN-MAKERS

The mythology of the Australian Aborigines was the cornerstone on which their way of life was built. Their myths perpetuated the traditions and beliefs, the rituals and ceremonies, that sustained and guided them for tens of thousands of years.

One of these beliefs handed down from the Dreamtime days was a sturdy faith in the magical powers of the rain-makers. These powers were most important to Aboriginal welfare in Central Australia, that harsh land of extremes where water is the essence of life.

The Aborigines of these desert regions displayed an uncanny instinct in their search for water, but in times of drought the rain-makers became awesome personalities. They were the experts whose gifts often meant the difference between life and death to the tribes.

The Arunta, Ilpirra, Kaitish and Unmatjira tribes, who occupied the dry areas north and south of Alice Springs, had many Dreamtime ancestors. Among these mythical people, Irria, Inungamella and Ilpailurkna were potent rain-makers; men whose gifts could make the deserts bloom.

Irria's rain-making rituals revolved around the black cockatoo, the bird appointed by the Dreamtime spirits to bring thunder and lightning down from the north. Only Irria could wear cockatoo feathers in his hair.

Irria taught Inungamella how to make rain, and gave him many gypsum stones which, when correctly sung over, produced the rainclouds they resembled.

Ilpailurkna's magical power was associated with the yamstick. This was painted with red ochre and decorated with white feathers which, when blown off into the sky, were transformed into clouds.

And in the places where the ancestors established totem rain-centres, their namesakes used the same magic to conjure up rain well into the present century. Even today these areas are lush and green and have a relatively high rainfall.

101 x 91 cm Mr Samuel and Mrs Wendy Olenick

THE BLESSING OF FIRE

One of the many variations on the origin of fire is the Aboriginal myth which relates how in the beginning there was no warmth and the only light was from the stars. This was the way of life for the Aborigines until the time came when a man and his wife, after a heavy thunderstorm, saw a strange glow where a bolt of lightning had struck an old log.

Puzzled by this weird sight, they covered it with bark in an attempt to hide it, but the bark suddenly burst into flame. This frightened them so much that they went to their tribal chief, a noted man of magic, and asked him to destroy the unknown thing they had found.

But when they returned to the now blazing log, and felt the comfort of its warmth, the chief realized that his companions had found something that would give his people light to dispel their darkness, and heat to keep them warm.

He gave a large torch of blazing wood to the woman and a smaller torch to the man, and so that the twin blessings of light and warmth would never be lost he sent them up into the sky to become the sun and the moon. He divided the rest of the burning log among the members of the tribe, and told them to place a coal in every tree so that the spirit of fire would always be available to everyone.

With fire to cook their food, keep them warm and light their darkness, life suddenly became so much easier that the Aborigines increased in numbers and gradually spread over their new land. The use of fire not only altered man's way of life, but set him apart from the rest of creation as nothing else could have done.

The Blessing of Fire — Ainslie Roberts

91 x 86 cm Mrs Melva Roberts

THE SUDDEN DARKNESS OF THE NINGAUIS

The Ningauis live in the dense mangrove swamps of an island, Imaluna, that lies off the northern coast of Australia. They resemble the Aborigines, except that they are small people, about two feet high, with long hair and short feet. These little people gather their food only in the darkness, and because they do not know how to make fire, the crabs and shellfish from the swamps, and the edible plants from the jungle, all have to be eaten raw.

Should an Aborigine go near to the homes of the Ningauis, one of them, calling out 'Eeh', will cause the whole place to become pitch-dark. And although the offender can bring the light back again by striking the trunk of a mangrove tree with a stick, the Ningauis, taking advantage of the darkness, will have disappeared. Therefore, no-one has ever seen a Ningaui, although the Aborigines often hear them calling to each other.

When, at night, the Ningauis perform their secret rituals and chant their songs, their home is as brightly lit as in the daytime. There are tales of hunters who, lured by the songs and light, have ventured into the swamps to find out what was happening. But as soon as the intruders were detected, the Ningauis made the swamp grow so dark, and the mangrove trees bend so closely together, that the strangers lost their way and died.

68 x 91 cm *Private collection*

THE CAPTURE OF THE FIRST FIRE

Many different types of terrain and climate may be found within Australia, and because Aboriginal beliefs were intimately associated with the type of country in which the tribes lived, many myths with a common basis varied according to the locality.

One of the most important factors in Aboriginal life was fire and its benefits. There are many different stories explaining how it was first obtained. Some stories say that a bird brought it to the people, others describe a tribesman's dangerous journey to obtain fire from a burning mountain, and in some myths the gift of fire resulted from lightning setting fire to a tree.

Most fire-myth variations share common themes of greed and reprisal. There is a selfish person who discovers the secret of fire, but keeps it to himself, and there are those who use courage and ingenuity to take it from him so that it can be shared.

A fire-myth from the Murrumbidgee region is typical of this construction. It tells how Goodah, a noted magician, captured a piece of lightning as it struck a dead tree during a storm. He imprisoned it as a convenient way to make fire for his own use, and ignored demands that he share this wonderful discovery.

At last the tribe became so enraged with Goodah that a group of elders called up a whirlwind just when Goodah had made a fire with his piece of lightning. The whirlwind picked up the fire and scattered it all over the country, and fire became common property when members of the tribe gathered up enough burning wood to make fires for themselves.

To escape the jeers and laughter of the tribe, Goodah fled to the hills to sulk, and to plan revenge.

91 x 68 cm Messrs R., W. and C. Kemp

LAUGHTER AT DAWN

When the world was young, everyone had to search for food in the dim light of the moon, for there was no sun. Then came the time when the emu and the brolga, each of whom was sitting on a nest of eggs, had a violent argument over the excellence of their chicks. Finally the angry brolga ran to the nest of her rival and, taking one of the eggs, hurled it into the sky, where it shattered against a pile of sticks gathered by the sky-people.

The yolk of the egg, bursting into flame, caused such a huge fire that its light revealed, for the first time, the beauty of the world beneath. When the people in the sky saw this beauty, they decided that the inhabitants below should have day and night.

So every night the sky-people collected a pile of dry wood, ready to be set alight as soon as the morning star appeared. But this scheme was not successful, for if the day was cloudy the star could not be seen and no-one lit the fire. So the sky-people asked the kookaburra, who had a strong voice, to call them every morning.

When this bird's rollicking laughter is first heard, the fire in the sky throws out but little heat or light. By noon, when the whole pile of wood is burning, the heat is intense. Later, the fire begins to die down until, at sunset, only a few embers remain to colour the western sky.

It is a strict rule of the tribes that nobody may imitate the kookaburra's call, for such an act might so offend the bird that he will remain silent. Then darkness would again descend upon the earth and its inhabitants.

68 x 91 cm Mr Basil Sellers

THE GYMEA

One hot day in the long-ago Dreamtime, an Aboriginal tribe took refuge from a summer storm in one of the many huge caves in the mountains of New South Wales. The storm was so violent that it tore up every tree in the valley where they lived, and the great deluge of rain caused a landslide which blocked the narrow entrance to the cave.

The imprisoned tribe, terrified and in darkness, seemed to be doomed. But Bullana, the strongest and most courageous of the tribal warriors, found a narrow crevice that led up to the surface. With great difficulty he pulled and squeezed himself up until he emerged into the sunlight, but none of the others were strong enough to follow him.

Bullana determined to do all in his power to keep his people alive. Day after day he hunted, and speared fish in the river, and he made a long rope to lower food down into the cave. Many times each day he climbed up the mountain to let food down to the tribe which depended upon him.

At last this constant heavy work and responsibility took its toll on even Bullana's strength. One day he slipped and fell into a ravine, breaking so many bones that he seemed unable to go on. But although he was so exhausted and in so much pain that he could only crawl, he still tried to hunt and fish for his tribe.

The effort was hopeless, and those in the cave began to die. The time came when Bullana knew he must abandon his struggle to save them, and he collapsed among the torn-up trees and tangled undergrowth of his beloved valley.

As he died, his hand grasped a small plant. As the spirit left him, this plant instantly grew into a mass of long broad leaves, and the great white flowers which burst from the centre became red with his blood. This is the plant we know today as the gymea, or gigantic lily, and it gains its strength and endurance from the spirit of Bullana. The flower spike and the roots have been used as food.

Countless centuries after the sudden growth of the gymea, a group of white men discovered a way into the huge old cave and found that the floor was covered with the tangled skeletons of Bullana's tribe.

91 x 68 cm Commander and Mrs R. Brasch

THE FIRST DEATH

Purukupali, one of the great creators of the Tiwi tribe of Melville Island, had an infant son, Jinini, whom he loved very much. But one day Jinini died. His mother, Bima, had neglected him while she was with her lover, Japara.

On hearing of the child's death, Purukupali became so enraged that he beat his wife over the head with a throwing-stick, and hunted her into the jungle; he then attacked her lover with a club and covered his face with deep wounds.

Despite this, Japara wanted to help the anguished father to restore his son to life within three days. But Purukupali angrily refused the offer. He picked up the dead body of his son and walked into the sea, calling loudly as the waters closed over his head, 'As I die, so all must die and never again come to life!'—a decree that brought death to all the world.

The place where Purukupali drowned himself is now a large and dangerous whirlpool in Dundas Strait, between Melville Island and the mainland. In this place the current is so swift and strong that any Aborigine attempting to cross the maelstrom in a canoe would be drowned.

When Japara saw what had happened, he changed himself into the moon and rose into the sky, his face still bearing the scars of his wounds. But although Japara cannot entirely escape the decree of Purukupali, and has to die for three days each month, he is eternally reincarnated.

68 x 91 cm *Private collection*

THE FIRST KANGAROO

One Australian myth relates how the first kangaroos were blown to the Australian mainland by a violent windstorm. The creatures became exhausted on that journey, for they could not land, even though their hind legs had grown longer in their attempts to gain a foothold.

A party of Aborigines were out hunting when this extraordinary storm of wind swept across their country, uprooting the trees, tearing the grass and shrubs from the earth, and driving the Aborigines into the shelter of the rocks. As the hunters looked up at the swirling debris they saw the kangaroos being carried along by the storm.

Never before had the Aborigines seen such strange animals, with their small heads and small arms, large bodies and tails, and long legs with which they were always trying to touch the ground, only to be swept into the air by the next blast of wind. But during a short lull in the storm the hunters saw a kangaroo become entangled in the branches of a tree, fall to the ground, and hop away.

Knowing that so large a creature would provide food for many people, the whole tribe moved to the locality where the hunters had seen the kangaroo, for it was good country with streams of running water, much fruit on the trees, and grass on the ground.

But it was a long time before Aborigines learnt how to capture kangaroos, the largest and swiftest of all the Australian animals.

68 x 91 cm Sir Robert Menzies Estate

THE BONEFISH TREE

This myth from northern Australia relates how the hunters of the tribe are able to increase the supply of bonefish (bony bream), which, like all food that is taken from the rivers and the sea, varies in quantity from one season to another.

In the beginning, when all the creatures, birds and plants of Australia had human form, Wilkalla the bonefish-man quarrelled violently with his sister. During the fight he threw a spear at her, and it sank so deeply into her head that she could not draw it out again. So she transformed herself into the mangrove, and Wilkalla's spear is the stalk which rises from the mud when a new mangrove plant is growing. Ever since then, the mangrove seeds have been an important item in the diet of the Aborigines.

But before Wilkalla's sister transformed herself into the mangrove, she struck Wilkalla a fatal blow across the back with her digging-stick. As he was dying, he called to the other hunters of his tribe to carry him to a huge bloodwood tree standing on the banks of the river.

His spirit went deep into the earth, and into the roots of the tree which draw water from the river. It stayed there forever, to make sure that the tribe would always have enough fish in the river for their food supply.

And to this day, whenever the fishing is poor, the tribe knows that if they hit the bloodwood trees along the river, Wilkalla's spirit will send many fish out into the water for them to catch. And the bonefish still carries on his back the mark of his sister's digging-stick.

91 x 68 cm *Private collection*

THE KOSCIUSKO BOGONG MOTH

For hundreds of years, the Bogong moths of the Snowy Mountains were a regular part of the summer food supply of the Aboriginal tribes in the area.

These drab, dull-coloured moths migrate to the mountains each year from the pastures and winter crops of south-eastern Australia. Collected from their resting-places in the granite outcrops, they were roasted in their thousands for their sweet, walnut flavour.

But the Bogong moths were not always dull and drab.

Indeed, long ago in the Dreamtime, one of the most beautiful of all creatures was Myee the moth. With her dazzling multi-coloured wings, she lived among the grasses of the riverbank. But she often wondered, and yearned to find out for herself, why the mountains high above were covered in white.

Her husband, Bogong, often warned her not to leave the safety of the river grasses. But one day, Myee's curiosity became too much for her and, as the sun was setting, she flew up towards the mountains. She reached them just as snow began to fall. The snow beat the fragile Myee to the ground, and soon covered her.

Myee did not die. She lay covered by the snow until spring. But as the snows melted, Myee's beautiful colours also drained away. As they did so, they ran into and coloured the new spring flowers of the mountains.

That is why, today, the colours of the Bogong moths of Mount Kosciusko are generally dull and lifeless, and only the springtime and summer wildflowers of the mountain carry the Dreamtime colours of Myee, the first Bogong moth.

104 x 79 cm Mrs Melva Roberts

WARATAH AND THE BLIND HUNTER

Wamili was a great hunter who, with the simple weapons of the Aborigines, supplied his people with kangaroos, emus, bandicoots and other game. No-one was more skilful than Wamili in tracking the creatures to their hiding-places; and no other spear travelled as quickly or as accurately to its mark.

But although Wamili spent most of his time hunting, the delicacy he most liked was the honey of the scarlet waratah, and during the period of its blooming he enjoyed many hours collecting it.

One day a flash of lightning struck a nearby tree and hurled Wamili to the ground, where he lay unconscious until his companions found him. Although he appeared to be uninjured, it was soon evident that their famous hunter was blind.

No longer could he hunt; nor, when the trees were flowering, could his fingers distinguish the blossoms of the waratah from other flowers of the same size and shape. As some of them were poisonous and others were filled with ants, not being able to distinguish between the blossoms caused Wamili much distress.

Kurita, the wife of Wamili, was so unhappy over the plight of her husband that she sought the help of the Kwinis, the tiny spirits of the bush, who agreed to make the pistils of waratah blossoms more rigid than those of the other flowers. And from that time on, Wamili, now able to find the waratah flowers by touch alone, could search confidently for his favourite honey.

68 x 91 cm *Private collection*

KALA CREATES THE SEA

Before the first sunrise, all was darkness. The surface of the earth was smooth and without feature. No hills, valleys or watercourses broke its surface, no trees covered its nakedness, no calls of birds punctuated its silence.

Then, during those far-off times, Mudungkala, old and blind, rose out of the ground. She carried three infants in her arms: a boy and two girls. No-one knows from where she came—nor, after she had finished the creation of the land of the Tiwis, to what place she went.

Crawling on her hands and knees, she began to travel northward in a wide arc. The water that bubbled up in her track became Dundas Strait, the swift-flowing channel that now separates the east coast of Melville Island from the mainland. Then she turned westward, forming the northern shores of Melville Island and making occasional journeys inland to create bays and rivers.

And so she continued, her track becoming the waterways of the land, until she reached her starting-point. On her last journey she created Clarence Strait, thus completely separating the land of the Tiwis from the rest of Australia.

91 x 68 cm *Private collection*

MOPADITI
AND COCKATOOS

The fear of the spirits of the dead, and the desire of the living to please them, form the basis of many Aboriginal myths and complicated burial ceremonies.

The people of Melville Island believe that the spirits of the dead, the Mopaditis, live in self-contained communities. They resemble the Aborigines in appearance except that their bodies, having no substance, are only nebulous images of their former selves. No living person has ever seen a Mopaditi, for they are invisible by day, white in the moonlight, and black in the darkness.

The spirit of a newly dead person stays near the grave until the completion of the burial rituals. It then sets out on a long flight to its future home, accompanied by a flock of screaming black cockatoos, who warn the dwellers of the Aboriginal 'heaven' that a new spirit is on its way.

No matter what its previous state, the Mopaditi is transformed into a young person of good health and equable temperament, for here the spirits must all be healthy, happy, and at peace with one another.

Normally, these spirits remain in their eternal home, but, now and again, some of the more recent arrivals return to their previous camping-places and watch the burial rites of old friends.

When the ceremonies are over and the Aborigines are asleep, the spirit-people repeat the rituals, performing the same dances and chanting the same songs until the glow of the Sun-woman in the eastern sky warns them to hasten back to their new home.

68 x 84 cm Mr and Mrs Charles E. Hulley

MAN OF MAGIC

The medicine-man is a person in whom the Aborigines have much faith. Yet he has a family, he hunts with his companions, he takes part in the secular and ceremonial life of his tribe, and he is subject both to sickness and to death. But he is a man apart, because the spirits of dead medicine-men, the Wulgis, have admitted him into their world of healing and magic; a world that few Aborigines can enter.

When the Wulgis notice an Aborigine who shows more than ordinary interest in the psychic life of the tribe, they choose him to become a medicine-man.

The Wulgis wait until the initiate is asleep, take the spirit from his body, and change it into the form of an eaglehawk. Then they conduct it into the sky, where it is shown many wonders and the secrets of magic and healing which are known only to the medicine-men. At dawn, the spirit of the initiate is taken back to his camp, transformed from that of an eaglehawk to that of an Aborigine, and returned to his own body. These journeys are repeated many times before the initiate has learnt all the secrets of his profession.

On return to his ordinary life, the newly initiated medicine-man has many new powers; he can heal the sick, find the spirits of children who have lost themselves in the darkness, and hunt the malignant night-spirits from the camps.

Occasionally the medicine-man will seek the help of a Wulgi to cure an Aborigine suffering severe body pains. The Wulgi goes inside the patient and searches until it finds an object such as a stick or stone, which has been placed there by an enemy. The Wulgi gives this to the medicine-man, who shows it as evidence that the cause of the pain has been removed.

It is said that the patient always recovers. No Aborigine ever doubts the ability of a medicine-man to cure most forms of sickness, or to overcome the effects of evil spirits.

68 x 91 cm *Private collection*

THE TRANSFORMATION OF BURNBA

The hawk-man, Wabula, was without a wife. One day he visited a neighbouring tribe and was attracted to an unmarried girl, Burnba. Wabula went to the nearby beach, caught some lobsters, and cooked them. Then he returned to the camp and offered them to the girl, who, much to his disgust, would have nothing to do with him.

Wabula was determined to capture her. He retired to a spot out of sight and hearing of the camp, and there he built a bark hut. That night he returned to the sleeping camp and carried Burnba away by force, placed her in the hut, and blocked up all the openings so that she could not escape.

Afraid and lonely, Burnba cried all night for her father to help her. He was a skilled magician and had a spearthrower with which he had performed many wonders. The first time he rubbed it, a heavy wind sprang up and grew stronger and stronger. It blew violently upon the bark hut, which shook so much that cracks appeared in it everywhere. The magician rubbed the spearthrower a second time, and transformed his daughter into a butterfly. In this form she was able to escape through one of the cracks.

At last the wind lifted the bark hut off the ground and Wabula discovered that Burnba had gone. Still yearning for the girl, he changed himself into a hawk, so that he could always live in the same element as Burnba.

68 x 91 cm *Private collection*

THE PARROTFISH ROCK

This painting depicts the myth of the parrotfish-man, Yambirika, who in the long-distant past made a camp on Bickerton Island in the Gulf of Carpentaria.

After living there for a while, he became dissatisfied with the site. So he dug a hole through the ground (which the Aborigines of that country believe is just resting on the surface of the ocean) and entered the sea. There he created two magical places where the Aborigines, by performing rituals, are able to increase the number of parrotfish.

The first of these two places, Talimba, is a loosely arranged circle of stones on the seashore where the sand within the circle is heavily impregnated with the spirits of parrotfish. At the breeding-time of these fish, the Aborigines take handfuls of the sand and cast it in all directions, at the same time chanting a song which asks that parrotfish be plentiful everywhere.

At Bartalumba, the other magical place, the parrotfish-man has been transformed into a rock. The top of this rock projects only a few feet above the sea, and the ritual consists of breaking off small pieces and throwing them in all directions, meanwhile chanting the same song as at Talimba. The Aborigines believe that these rituals are always effective, and not only multiply the number of parrotfish and other sea creatures in the locality but make them easier to catch on their fishing-lines.

68 x 91 cm *Private collection*

GARKAIN AND THE TRESPASSER

The Aborigines of Arnhem Land people their country with a host of spirit-beings. These beings still live in the deep caves and high crevices of the eroded plateau, among the rushes and waterlilies of the swamps, and under the tall trees of the stringybark forests.

The most feared of them are the Namarakains and the Nabudi women. The Namarakains are always trying to steal the spirits of sick people; while the dreaded Nabudi women, from sheer malice, project invisible barbs into the bodies of solitary men who travel by themselves, and make them sick.

But there are others who are generally less dangerous, though they may become violent if anyone trespasses in an area they regard as their special domain. Among their number is a dumb spirit-man, Garkain. His home is in the dense jungle along the banks of the Liverpool River. If anyone should venture into the jungle, Garkain, who can fly as well as walk, will wrap himself around the intruder and smother him with the loose folds of skin which are attached to his arms and legs. Since Garkain has neither tools nor weapons, he has to catch what living creatures he can with his bare hands. He does not know the secret of fire, so he has to eat them raw.

However, most of the spirit-beings of Arnhem Land are harmless, and never molest the Aboriginal people.

91 x 68 cm *Private collection*

THE DROUGHT-BREAKER

The Aborigines believe that the universe is divided into three worlds: the underground world Jimbin, the earth world Jalala, and the sky world Kurwul.

Kurwul, the sky world, is the home of the stars, the moon and the sun. It is also the home of the thunderstorms, which rest there quietly during the dry seasons.

But when it is time, the Monsoon-man awakens from his long sleep and gathers together Yoora the clouds, Yundarra the thunder and Wabili the lightning, and brings them all down close to the parched earth.

The Monsoon-man's spear becomes the flash of lightning as he thrusts it down into the earth, and this is the signal for the thunderclouds to release the torrents of rain which replenish the earth and end the drought for another year.

91 x 122 cm Mr D. and Mrs B. Mackenzie

BIRTH OF THE BUTTERFLIES

When the world was young, the birds and animals had a common language and there was no death. No creature had any experience of death's mystery, until one day a young cockatoo fell from a tree and broke its neck. The birds and animals could not wake it, and a meeting of the wise ones decided that the spirits had taken back the bird to change it into another form.

Everyone thought this a reasonable explanation, but to prove the theory the leaders called for volunteers who would imitate the dead cockatoo by going up into the sky for a whole winter. During this time, they would not be allowed to see, hear, smell or taste anything. In the spring they were to return to earth to relate their experiences to the others. The caterpillars offered to try this experiment, and went up in the sky into a huge cloud.

On the first warm day of spring a pair of excited dragonflies told the gathering that the caterpillars were returning with new bodies. Soon the dragonflies led back into the camp a great pageant of white, yellow, red, blue and green creatures—the first butterflies, and proof that the spirits had changed the caterpillars' bodies into another form.

They clustered in large groups on the trees and bushes, and everything looked so gay and colourful that the wise ones decided this was a good and happy thing that had happened, and decreed it must always be so. Since then, caterpillars always spend winter hidden in cocoons, preparing for their dramatic change into one of spring's most beautiful symbols.

68 x 91 cm *Sir Robert Helpmann Estate*

YULU'S CHARCOAL

The huge coal deposits of Leigh Creek in South Australia were first discovered by white men in 1888, when coal-bearing shale was found during the construction of a railway dam. But the old Aborigines of the Flinders Ranges area insisted that their people knew about the coal deposits long before the coming of the Europeans. They called them Yulu's Charcoal, and Dreamtime mythology explains the origin of these deposits.

Yulu Yulura was a giant Aboriginal ancestor, who decided to attend an initiation ceremony to be held in the place we know today as Wilpena Pound. During his long journey eastwards to the Pound, Yulu lit many fires to announce his coming.

These fires were so extensive, and used up so many trees, that the charcoal left behind formed the present coal deposits and made treeless the vast areas to the west of the Flinders Ranges.

The first open-cut mining in the 1940s disclosed that one of the coal basins was indeed burnt out, and the later discovery of the burnt shales of the Northern Basin was further confirmation of Yulu's spectacular journey of so long ago.

68 x 91 cm Mr and Mrs Charles E. Hulley

THE SCORCHING OF THE BIRDS

An old eagle, Wildu, and his two young kestrel wives, once lived in the rugged Flinders Ranges of South Australia. It was the duty of Wildu to train his nephews, a crow, Wakala, and a magpie, Kinita, in the rules and beliefs of the tribe. But the lives of the nephews were made so unbearable by the exacting demands of Wildu that they speared him.

Thinking him dead, the nephews and their friends held a corroboree. But the old eagle was brought back to life by the magical chanting of his two wives, and from the summit of a high mountain he could see the birds and animals dancing to celebrate his death. The crow and the magpie stood out from the grey-coated animals, because both had glossy-white plumage.

Now Wildu, knowing of a cave in a group of boulders not far from the corroboree ground, estimated that a sudden squall of rain would drive all the performers into the cave for shelter. So the eagle asked his wives, the kestrels, to go into the air again and flap their wings, this time to draw up a heavy storm of rain from the south.

Everything happened just as Wildu had planned. When the rain started to pour down, the performers rushed to the cave. The animals went in first, then the magpie, and finally the crow, their bodies almost blocking the entrance. This suited the eagle very well. Quickly, he and his wives covered the opening with a huge pile of grass and dead branches, and set them on fire.

When the fire died away, it was found that the wallabies, bandicoots and other creatures had escaped unmarked. But the crow and the magpie were not so fortunate; the glossy plumage of the crow, who was nearest to the fire, was scorched completely black, while that of the magpie, further from the fire, was scorched only in parts. And, the Aborigines explain, that is the reason why all the crows are black, and the magpies black and white.

68 x 91 cm *Savill Galleries*

59

MANGOWA AND THE ROUND LAKES

Mangowa, the hunter, waiting silently on the edge of the lake to spear some fish, saw a young and beautiful girl, Pirili, paddling her shallow bark canoe toward the distant shore.

The sight of the graceful body of Pirili, and the ease with which she propelled her simple craft, filled Mangowa with an overwhelming desire to possess her. But, although the old men of the tribe agreed that Mangowa could have Pirili as his wife, she refused to agree to the marriage.

To court her favours, Mangowa brought her the best fish he had speared, but she allowed them to rot in the sun; he gave her scarlet feathers for her hair, and the softest of possum-skin cloaks, but still she remained adamant to his wooing. Overwhelmed with desire, Mangowa pursued Pirili wherever she went, pleading his cause and protesting his affection until one day, in desperation, he seized the girl and carried her to his camp. Pirili, frantic with terror, tore herself from his arms and, flying into the sky, asked the women of the Milky Way to protect her from Mangowa's unwelcome attentions. Furious that the girl had escaped him, Mangowa followed her and, tearing great handfuls of stars from the Milky Way, threw them at Pirili to drive her back down again.

But the people of the stars, disgusted over Mangowa's behaviour, banished him to earth, so that Pirili would always be safe in the sparkling constellation of the Seven Sisters. And the stars that Mangowa tore from their homes, falling to earth, made the circular lagoons that fringe the shores of the coastal lakes of South Australia.

68 x 91 cm Keith H. Kingsley Estate

MILAPUKALA, THE COCKATOO-WOMAN

When Jinini, the son of Purukupali, died, his father was so frenzied with grief that he drowned himself in a whirlpool off north-western Melville Island. In those remote times, when a death was to be mourned in the Pukamuni burial ceremony, it was the duty of Tukimbini, the yellow-faced honey-eater, to call the mythical beings together to carry out the rituals.

At the conclusion of the rites, they returned to their camps in various parts of the island to create food for the Aborigines who would later populate the land.

The cockatoo-woman, Milapukala, had her camp at Cape Fourcroy, on north-western Bathurst Island. She made a large freshwater lagoon, Milapuru, and then many rocky headlands and open plains around its shores. She then decreed that many food creatures should make this place their home, so that there would always be abundant food in the country she had created.

Her duties completed, the cockatoo-woman transformed herself into a cleft rock on the shores of the Milapuru lagoon. At fixed times every year, the Aborigines of that country assemble at the totemic rock and perform rituals to commemorate her exploits, as well as magically to increase the creatures and plants.

Nilapukala, the Cockatoo Woman — Ainslie Roberts, 1971

68 x 91 cm Private collection

THE MARK OF WALA-UNDAYUA

The Aborigines of northern Arnhem Land are afraid of the mythical lightning-man, Wala-undayua. During the dry season he spends most of his time in a deep waterhole in the Liverpool River, though sometimes he hunts for wallabies among the cabbage palms along its banks.

Wala-undayua looks on these palms as his personal property, and if anyone so much as touches their trunks, he will kill the offender with a lightning-flash. But should an Aborigine throw a stone into his waterhole, an even greater misfortune would result, for then the lightning-man, furious over this indignity, would rise into the air and create thunderstorms of such violence that everyone would be destroyed.

But it is when the monsoon rains begin that the lightning-man becomes most belligerent. Leaving his waterhole, he travels in the clouds, roars with the voice of thunder, and with his long arms and legs (which are the lightning-flashes) savagely strikes the ground, leaving the burnt-out forest and shattered trees of the devastated landscape as evidence of his wrath.

At the end of the wet season Wala-undayua returns to his waterhole, where he lives peacefully until the monsoon clouds again form in the sky to renew his violence.

71 x 91 cm *Private collection*

CREATION OF THE MILKY WAY

Nurunderi, after spending some time with Nepele, his brother-in-law, became increasingly unhappy because his wives were not with him. Having by then recovered from his exertions in capturing a huge cod, and creating a great river and all the fish in it, he decided to continue the search for his wives.

But as he prepared to move on, he realized that his quest would be over land and he would have no further use for the canoe which had carried him such a great distance. Not wishing to abandon so fine a possession, and noticing the many parts of the night sky where no stars shone, Nurunderi resolved to put his canoe to good use.

He selected the two highest sandhills in the area to stand on and lifted his canoe up into one of the dark spots in the sky, where it became the bright dusting of stars we call the Milky Way.

Nurunderi's two sandhills can still be seen at Mount Misery, close to the main road. In the language of the Jaralde tribe the word for 'canoe' is *juki*, and so they called the Milky Way *Ngurunderi Juki* or Nurunderi's Canoe.

86 x 122 cm Messrs R., W. and C. Kemp

BIRTH OF THE SEALS

After placing his canoe in the sky, where it became the Milky Way, Nurunderi set out on foot to recapture his wives. He created many of the natural features of the coastline as he did so, the most prominent of these being a rugged granite headland known today as Rosetta Head, or the Bluff.

From the high vantage-point, Nurunderi located his errant wives far to the west. After resting for a while on this headland, which the Aborigines later regarded as his sleeping body, Nurunderi cast four of his spears into the ocean before resuming his chase. Where each spear pierced the water a rocky island arose.

One of these was Seal Rock, a small island surrounded by dangerous reefs and isolated submerged rocks. And with the creation of Seal Rock came the birth of the hordes of seals which gave the island its name.

For countless centuries, until the coming of the white man, Seal Rock was the birthplace and playground of generations of seals. The white men killed them for their hides, meat and blubber, and rapidly reduced their numbers.

Today there are no seals on Seal Rock, but the haunting cries of the seabirds that nest on it remind us that long, long ago this was a place where nature was vital and unafraid.

91 x 101 cm Mr and Mrs Charles E. Hulley

THE EAGLE AND THE DINGO

The Australian Aborigines who lived on Melville Island, north of Darwin, collected their best ochres from Arunumpi, on the island's southern shores. At this place there are two large ochre deposits, one of yellow and another of white, which were used by the Aborigines for ceremonial body decoration and for painting their unique burial-poles.

But the locality also has a special significance. The tribal mythology relates how, during the great creation period, Mudati and his wife Kirijuna were camped at this spot when Mudati saw his wife's brother, Jurumu, coming towards them.

Mudati warned his wife not to speak nor even look at her brother, for so it had been decreed by the spirits. But the woman, who had not set eyes on her brother since they were children, took a quick look just to see how much he had grown.

Instantly, she dropped dead at her husband's feet. But even as he watched, he saw the body slowly transformed into the first dingo, rise to its feet, and slink away. The brother, Jurumu, was changed into the eagle.

Ever since then the dingo, ashamed of its disobedient action in those far-off times, keeps out of sight, and has developed the ability to merge with its surroundings to an uncanny degree.

The dingo slinking through the bush, and the eagle soaring high above her, remind Aborigines of Melville Island of the ancient spirit law: that once brothers and sisters have grown to be adults, they may no longer look at or speak to each other.

91 x 122 cm *Private collection*

CREATION OF THE COORONG BIRDS

During the Dreamtime, when all the birds were still Aborigines, they had a favourite fishing spot near the Murray mouth. When they used their nets they worked as a team, and the only man who was a misfit was the magpie-man; he was lazy and disliked the water. It was his duty to carry the firesticks so that a fire could be made to cook the fish.

One cold day, after the men in the water had made a good catch, they called out to the magpie-man to build a fire, so that they could warm themselves and cook the fish. But the lazy magpie-man, being away from the water and not feeling cold, said there was not enough wood to build a fire and urged the others to go on fishing.

This happened again and again, until the disgusted fishermen waded ashore and made their own fire. When all the cod, mulloway and perch had been shared, the only fish left were bony bream. These are so bony that they were seldom eaten, so the fishermen gave them to the magpie-man as a punishment.

This angered the magpie-man so much that he took a bream in each hand and attacked the rest of the party. In the commotion that followed the men turned themselves into birds, and many of them were splashed white with flying scales.

The pelican, his previously black body now partly white, jumped into the water, and the net he had carried was changed into the large pouch under his bill. The cormorants and ducks dived under the water to escape harm, and the coots ran into the reeds. The magpie, his black body also marked with the silvery scales, flew to the top of a cliff. To this day he keeps away from the water, and from the fishing birds with whom he once quarrelled.

Creation of the Currong Birds

86 x 122 cm Private collection

LINGA OF AYERS ROCK

This myth, handed down by the Pitjandjara tribe, relates how Linga, a little lizard-man, lived by himself near the place where Ayers Rock (Uluru) now stands. Linga had spent many days making a boomerang, and when it was finished he threw it to test its balance. The boomerang flew higher and higher into the air and spun across the desert until it buried itself in the soft sand of the great red sandhill from which Ayers Rock was later created.

Greatly distressed at the loss of such a fine weapon, Linga hurried to the spot and dug everywhere with his bare hands to find it. Today, many of the spectacular features of Ayers Rock are the result of Linga's frantic digging. The deep holes and gutters, which he made in the sand, have since been transformed into large potholes and vertical chasms in the steep face of the huge monolith.

Linga, forever associated with the sand in which he lost his boomerang, became the little sand-lizard. And, if you are quiet enough, and quick enough, you may surprise him alongside a small hole in some red sandhill.

If, in awe, you wonder how he survives in such an arid region, your curiosity is a tribute to the Aborigines of the desert. For countless thousands of years, and with only five simple tools, they gained an adequate living in an environment so harsh that no white man could live there unless he carried his own food and water.

68 x 91 cm *Private collection*

THE FIRST DAWN

The Aborigines of the Dieyerie tribe, in the far north of South Australia, believed that all living creatures were created by Pirra, the moon. This task was carried out under the direction of the Mooramoora, the great spirit who made all things. Pirra created people by first making two small black lizards. He then divided their feet into toes and fingers and, with a forefinger, formed the noses, eyes, ears and mouths. Pirra placed the creatures in a standing position, which they could not retain; so he cut off their tails and the lizards walked erect. They were then made male and female, to perpetuate the race.

But when these first men and women began to move about the land, guided only by the moon's light, they found it dark and bitterly cold because the sun had not yet been created. Weapons for hunting had not been developed, and the small animals caught for food had to be run down on foot.

The biggest creature in that far-off Dreamtime was the emu. It was many times larger than it is now, and the hunters knew that the flesh of an emu, could they but capture one, would provide food for the tribe for a long time. They made many attempts to capture the big bird, but it was so fast, and the world was so dark and cold, that they never succeeded. The emu always vanished into the darkness.

So the hunters held a great gathering, performed many ceremonies, and pleaded with Mooramoora to make their world warmer and lighter so that they could capture the emu. And Mooramoora listened to their troubles and made the sun, thus creating day and night.

61 x 84 cm Mr and Mrs Charles E. Hulley

JIRAKUPAI AND HERONS

During earliest times, the Aboriginal tribes had strict boundaries to their lands. Each tribal area was reserved: no member was permitted to venture beyond it and no outsiders were allowed to enter.

But a party of Melville Island men on walkabout ignored these tribal boundaries and wandered into forbidden territory. There they saw Jirakupai and his two wives beside a lagoon.

Jirakupai was famed as an expert in making many-barbed spears. He had just finished making a number of these weapons when the enemy Melville Island men rushed into his camp and, jealous of his skill, speared him in his back many times. But as they struck, Jirakupai plucked the spears out and cast them back at his aggressors. Then, howling loudly with pain, he picked up the spears he had just made and dived into the water to escape further injury. His wives, to avoid capture, changed themselves into birds and can be seen today as the herons that frequent the many mangrove swamps.

The next morning, his enemies saw Jirakupai floating in the water—no longer as a man but as a crocodile. The spear wounds in his back had grown into a spinal crest; his mouth, through shouting so much in his pain, had grown longer and larger; and his bundle of spears had been transformed into the vicious barbed tail.

68 x 91 cm Mr Burke M. Hyde Jnr

79

CREATION OF THE JENOLAN CAVES

The Aborigines of New South Wales believed that, in the Dreamtime, Mirragan the hunter tried to spear Gurangatch, a huge half-fish, half-reptile who lived in a deep waterhole in the Blue Mountains. After failing many times, Mirragan attempted to poison the water with hickory bark. But Gurangatch escaped by tearing up the ground along a nearby valley, so that the water from the waterhole flowed along after him.

Mirragan was relentless in his ambition to capture such a large creature, and he caught up with Gurangatch many times. Each time, they fought fiercely; but each time, Gurangatch escaped. Finally he burrowed into the mountains and created a huge cave.

The determined Mirragan then climbed to the top of the range, and drove his spear into the ground to frighten Gurangatch out of the cave. He drove his spear down in many places, and with every thrust Gurangatch dug further into the mountains until he had created a labyrinth of caves. At last he broke out on the other side and disappeared into the Joolundoo waterhole. Mirragan returned with the tribe's best divers, but none of them could dislodge the creature from this deepest of all waterholes.

The encounter between Mirragan and Gurangatch resulted in the formation of the Wollondilly and Cox rivers, the Jenolan and Wombeyan caves, the blowholes on top of the Blue Mountains and, in the places where they fought, the many deep waterholes in the two rivers.

The Aborigines always avoided these waterholes, believing that they were inhabited by the descendants of Gurangatch.

68 x 91 cm *Private collection*

THE LAST HURRICANE

Since creation times, the crows have been designated by their Dreamtime ancestors to be the keepers and controllers of the west wind.

This wild wind is the most dreaded of all winds—it can very quickly grow from gentle breeze to roaring gale. It brings with it lightning and thunder, and vast rainclouds that can flood the land and cause great hardship for the Aboriginal people.

From earliest memory, the crows have kept this wind confined within a great hollow log. Sometimes some of it escapes through cracks and holes, and then they have to chase it and bring it back in order to imprison it once more.

But the great log is slowly decaying, as all logs do, and one of the Aborigines' fears is that, one day, the log will not be strong enough to hold the west wind: it will come apart to release a great hurricane that will destroy the whole earth and all things that live upon it.

Among the tribes whose mythology includes this belief, great care is taken not to kill, or in any way disturb, the black crows; for should this be allowed to happen, disaster is sure to follow.

91 x 122 cm Mr and Mrs Fred Agar

THE WEEPING OPAL

A myth of central Queensland relates that in the days of the Dreamtime, when the world was young and the great creation events were taking place, a giant opal ruled over the destinies of men and women. This ancestral being lived in the sky, made the laws under which the tribes should live, and dictated the punishments to be inflicted on law-breakers.

The creation of this Aboriginal ancestor came about as a result of a war between two tribes. The fighting had gone on for so long that, at last, the combatants had broken or lost all their weapons. So they began hurling boulders at each other, and a tribesman threw one so hard that it flew upwards and lodged in the sky.

The boulder grew rapidly as the frightened warriors watched, until it burst open and revealed the flashing colours of a huge opal. The opal saw the dead and wounded warriors lying on the ground below, and it wept in sorrow.

Tears streamed from the opal in such profusion that they became a great rainstorm, and when the sun shone on the opal-coloured tears the Aborigines saw their first rainbow.

From that time on, the Aborigines of the area believed the rainbow to be a sign that someone had committed a crime against the tribal laws laid down so long ago, and that the tears of the opal were again falling in sorrow.

91 x 91 cm Mr and Mrs Ron Trezise

ABDUCTION OF THE WHITE SWANS

In the Dreamtime there were no black swans; all swans were white. This remained so until the time came when two swans landed on a lagoon on Australia's north coast, not knowing that the lagoon was the property of the eagles. The eagles, angry with this trespass, savagely attacked the two swans and tore out most of their feathers. They then picked up the swans and carried them far to the south, where they left them in the great desert to die, bald and unprotected.

But as they lay in agony, the swans heard the call of the black crows and, looking up, saw a huge flock of the birds darkening the sky. As they flew over, each of the crows plucked a black feather from its own body and let it fall on the swans.

'The eagles are our enemies too,' they called. 'Our feathers will clothe you and help you grow strong again.'

And so the swans recovered and flew on south, where today the black feathers of the crows cover almost every part of the swans' bodies. But the white feathers on their wingtips and the blood on their beaks are reminders that the eagles are still their enemies.

91 x 94 cm *Miss Allyson Parsons*

GOOLAGAYA AND THE WHITE DINGO

The Aborigines often tell their boys and girls the story of a spiteful woman, Goolagaya, who, having no children of her own, was intensely jealous of other women who were more fortunate.

Her tale-bearing and gossip had caused almost every quarrel in the camp, especially those between husbands and wives, or mothers and their grown-up daughters. In consequence, Goolagaya was so much shunned and disliked that her only companion was a savage white dingo, which followed its mistress everywhere. But in spite of her enmity towards adults, Goolagaya was always kind to children, and often, when their parents were not watching, amused them with games or gave them titbits of food.

One day, after a violent quarrel with a woman named Naluk, Goolagaya planned to take revenge by giving her a great fright. She waited until there was no-one about, then picked up Naluk's baby and hid it under a low shrub at the edge of a distant lagoon, expecting that the infant would soon be found. But her plans miscarried, for the baby, on waking, crawled to the bank of the lagoon, fell over the edge into the water, and was drowned.

This accident so enraged the Aborigines that they killed both Goolagaya and her dingo, burying them deeply in the mud of the lagoon so that never again would they cause any trouble. But though their bodies remained under the ground, their spirits escaped and made their home in the trunk of a misshapen tree at the edge of the water.

Every night, just as the sun is sinking below the horizon, the spirits of Goolagaya and her companion leave the tree, ready, when darkness comes, to steal any wandering child. But Goolagaya is rarely successful, for the children, warned of the dangers of the dark, fear to leave the light of their campfire.

74 x 91 cm Private collection

KOOLULLA AND THE TWO SISTERS

The Aborigines of southern Australia had a belief that two sisters lived deep in the ocean in a vast forest of kelp. Sometimes they came up on the shore to search for crabs and shellfish among the rocks, and on one of these occasions they were so busy at their task that they did not see that Koolulla, who was a renowned hunter, was camped nearby.

Koolulla had been casting his net in the shallows, and had just finished cooking his catch when he saw the sisters. He was so impressed by their beauty that he resolved to capture them, so he picked up his net and a large firestick from the fire and crept close enough to the two women to throw his net over them. One wriggled out from under it and jumped back into the sea. Quickly, Koolulla secured the net around his captive and leaped into the water in chase of her sister. As his firestick sank it created a burst of sparks which floated up into the sky.

Koolulla swam all that day in pursuit of the woman, but she finally led him into the kelp forest. There, exhausted and entangled in the great mass of seaweed, he sank to the bottom and was transformed into the shark, compelled always to hunt the deep waters in search of the woman he lost.

The sister on the shore, unable to free herself from Koolulla's net, eventually died and was changed into the evening star. The sparks from Koolulla's firestick may still be seen in the sky. They are the first stars to appear as night falls, and the brightest of them all is the evening star, keeping watch over her sister who still lives in the underwater forest.

91 x 122 cm Art Australia

THE SEARCH FOR MOODAI

Long ago in the Dreamtime, Moodai, the possum-man, was a mighty hunter who kept not only his own but also many other families of his tribe well supplied with food. On his short hunting trips he often took his two small sons. They were always asking Moodai to tell them more about the great moon that sometimes hung overhead in the starlit sky.

He told them the stories of how the moon grows and how it is eaten away by the sun, which chases it across the heavens each month. The boys' fascination with the moon deepened.

One bright evening when the moon was full and they were out hunting, Moodai saw a very tall but very thin tree that looked likely to yield a good meal of witchetty-grubs. Instructing his sons to hold the trunk of the tree steady, Moodai began to climb up and up. When he reached the very top, he called out to the boys that he could touch the moon. In their excitement they let go of the tree, which began to bend and fall as its roots were torn from the ground.

Moodai gathered himself and jumped to the moon for safety as the great tree fell to earth. The two boys frantically climbed every tree they could to try to reach their father in the moon, but none was tall enough.

Ever since then, especially at the time of full moon, the boys and other possums from the tribe can still be seen climbing the tallest trees in an endless search for the great hunter. Moodai still looks down on his own sons, who are the rare albino possums. They are the colour of the cold night moon—a special reminder of the fate of their father.

The Search for Moodai

101 x 96 cm *Private collection*

WITANA'S OCHRE MINES

Witana was a giant mythical being of the tribes of the northern Flinders Ranges in South Australia. He created many of the natural features of that beautiful country; its steep-sided gorges, brightly coloured cliffs, and permanent waterholes. Witana also established the rites of initiation, particularly the Wilyeru body-scarring ceremony through which all Aboriginal youths must pass before they can achieve full tribal manhood.

According to the traditional stories, Witana once camped at Wataku-wadlu, in the middle of the Flinders Ranges. While he was there he made a cut in each of his arms, to obtain the blood with which to decorate youths taking part in the initiation rituals. The pool of blood which ran from one arm was transformed into a deposit of red ochre, and that from the other arm became a reef of black pigment.

In times past the local Aborigines, as well as those of more distant tribes, made annual pilgrimages to Wataku-wadlu to gather these pigments for the initiation of their boys. The red ochre was used for the circumcision ceremonies, and the black pigment for the body-scarring rituals of the Wilyeru.

Ntana's Ochre Mines

91 x 91 cm Dr D.H. LeMessurier

THE DESERT ICE-MEN

This myth from the Mount Conner area of Central Australia describes how the Ninya ice-men are the creators of frost, ice and cold winds. They differ little in appearance from the Aborigines except that their bodies are covered with hoarfrost, and their hair and whiskers are icicles.

The Ninya live in huge underground caverns, the ice-covered walls of which are swept continuously by howling cold winds. The only entrance to their home is on a low island in the Unagaltja salt lake, and close by are some boulders and stunted mulga trees.

During the hot summer months the ice-men cluster happily together in their glacial home, but when winter comes they roam the desert during the night, freezing the waterholes and leaving the ground covered with ice and frost, which causes deep, painful cracks in the soles of the Aborigines' feet.

Sometimes, should their return be delayed, the ice-men have to run to reach their underground caverns before the sun rises, knowing that its warmth would melt much of the ice on their bodies and so reduce their powers to create winter cold. On these occasions, the hurrying passage of the men creates the icy winds that sweep across the desert at dawn.

91 x 96 cm Mr and Mrs Charles E. Hulley

THE TREES BORN OF FIRE

Wapanga, although a noted warrior, was not a popular man. His preoccupation with his good looks, and his arrogant attitude, made the people of his tribe avoid him. Feeling an outcast, he took to roaming far from camp on his hunting trips, until one day he saw a young woman, Tilpana, in a neighbouring camp.

Wapanga was so captivated by her beauty that he returned to the place many times, until at last he found her alone. He asked her to go away with him, but Tilpana, liking him no better than did the women of his own tribe, made her feelings plain and ran back to her people.

Furious and humiliated, Wapanga determined to have his revenge, not only on Tilpana but on the whole of her small tribe. So on a day of fierce heat and high winds he set light to the dense scrub near her camp. The small flames quickly became a roaring bushfire, which swept down on the camp with such speed that few escaped alive.

Tilpana was one of the few who outran the fire, and when she saw Wapanga standing in the ashes gloating over the dreadful carnage, she showed herself in the open and Wapanga gave chase. Tilpana lured him into a patch of thick scrub, and waited.

Now Tilpana had many times concealed herself to watch the secret ceremonies of her elders, and this had given her much forbidden knowledge. Although too fearful to use it before, she now called on the spirits to help her and, when Wapanga was almost upon her, surrounded him with a ring of flame and smoke.

As Wapanga tried to escape from his fiery prison, he saw with horror that the seeds dropping from the trees burst into life as soon as they fell in the flames. They grew with such speed that he was instantly enclosed within a wall of growth so thick that he could not escape.

Exhausted, Wapanga fell into the flames and died. Tilpana, who had not managed her magic quickly enough to escape the fire of her own making, was badly burnt and, as punishment for using forbidden secrets, was transformed into the crow.

Ever since that time, the crow has been black, and the strongest seed germination in the Australian bush always follows a bushfire.

The Trees born of Fire

91 x 68 cm Mrs Dale Roberts

WURIU RETURNS TO THE EAST

Wuriupranala, one of the two daughters of Mudungkala the Creator and thus one of the first women, was given the task of keeping alight a torch of blazing bark. As the Sun-woman, she had to travel daily across the sky, the flames of her torch providing the world with light and heat.

Each dawn she would commence her journey from the top of a mountain high in the east. Before she set out, she powdered her body with red ochre, the dust of which, flying into the air, reddened the clouds of early morning. She carried her food in a palmleaf basket and her hair was decorated with a dingo-skin ornament.

At midday she made camp and, on a fire lit from her torch, cooked the food she had brought with her or had collected during the morning.

At last, in the evening, the Sun-woman would rest for a while on a mountain on the western horizon. Here she again powdered her body, creating the vivid sunsets.

Then she extinguished her torch and, having rested for a while beside the celestial lagoon, Kumpinulu, she began her return journey east along a path through the subterranean world, Ilara. On her way back, she was guided only by the glow from her smouldering torch.

68 x 91 cm *Private collection*

THE ORIGIN OF THE PLATYPUS

Naruni, youngest and most beautiful woman in her tribe, had been promised in marriage to a tribal elder. But she was attracted to the younger and more attractive Kuralka, who persuaded her to run away with him to the hill country. After many months the pair became conscience-stricken and returned to the tribe in disgrace. Naruni was transformed into a duck, and Kuralka was punished by being changed into a giant water-rat. Both were banished to a far-distant river.

Rejected by the land and her people, Naruni in due course hatched two eggs. To her horror, she found that they did not contain ducklings, but strange creatures with bodies of fur, webbed feet and duckbills.

So great was Naruni's disappointment, and so strong was her yearning for the solid ground and her lost tribal life, that she pined away and died. But her two children thrived in their watery home, and multiplied to establish the platypus family.

This is how the Aborigines explained the origin of the platypus to the early settlers of New South Wales. They also described its habits and how it reproduced. When the first platypus skin was shown to European scientists it caused a sensation, and they were so astonished that they said the beak and feet of a waterbird had been sewn to the skin of some animal.

After that, controversy raged for eighty years over how the platypus produced its young, until it was proved that the creature laid eggs and suckled its offspring. This strange link in the biological chain is unique to Australia.

The myth that explains the origin of the platypus is characteristic of the way Aborigines used fantasy to account for natural phenomena which, later, were to baffle European scientists for many years.

91 x 122 cm CSR

CREATION OF THE INMAN RIVER

In the Dreamtime of the Encounter Bay tribe of South Australia, an old man called Lime was visited by a friend, Palpangye, who brought him some bream, a river fish not then known in the area. Lime returned the favour by giving Palpangye some mullet he had caught in the sea that day. As the men sat by the campfire after eating the two kinds of fish, Lime told his friend he had enjoyed the bream so much that he wished there were rivers in the neighbourhood, so that he too might catch bream.

That night Palpangye, who was a noted man of magic, went into the hills and pulled a huge dead gumtree out of the ground. He turned it upside down, then thrust it into the earth and twisted it round and round. Water and fish flowed up and filled the hole he had made.

Palpangye did this in many places, and the great pools overflowed into each other until the water formed the Moogoora river and reached the sea. He then walked some distance to the east, where he created the Yalladoola river in the same way. These are the rivers known today as the Inman and the Hindmarsh, still favourite breeding-waters for bream.

When the time came for the old men to die, Palpangye transformed himself into a bird. Lime became a large rock on the shores of the bay, and the sea in its vicinity has ever since abounded in mullet. The myth records that women and children were never allowed to tread on the rock, but old people, because of their long acquaintance with Lime, were permitted to do so.

53 x 68 cm *Private collection*

TIRLTA AND THE FLOWERS OF BLOOD

At the time this story begins, the elders of a Central Australian tribe had decided that a young girl, Purlimil, should be given in marriage to a coarse and jealous old man, Tirlta. This was exceedingly bad news for Purlimil, for not only did she detest Tirlta, but she and a young man named Borola had already planned to marry and live with his relatives in a country far away to the east. That night, knowing that the decision was final, the lovers eloped and fled to the land of his people, where they set up their camp on the shores of a beautiful lake. There they lived happily for so long that they had almost forgotten Tirlta.

But after several years, Tirlta, his mind still full of hatred, assembled his relatives and attacked the people with whom Purlimil was living. Tirlta had planned to capture Purlimil for himself, killing everyone else in the tribe; but in the confusion of the attack Purlimil was slain along with the rest of the tribespeople, the blood from their wounds staining the ground where they lay.

The next season Tirlta returned to gloat over the bleached skeletons of his victims. But he saw no bones, only carpets of scarlet black-eyed flowers that had grown from the blood of the slain. Knowing by this that the spirits of the dead were still active and powerful, Tirlta turned to flee, but a spear thrown from a cloud overhead struck him lifeless to the ground.

The tears of the spirits turned the sweet clear lake to salt, and Tirlta and the spear that killed him are only small stones on its shores; but every season, Sturt's desert peas—or, as the Aborigines call them, the Flowers of Blood—spread their brilliance over the arid plains of the outback country.

68 x 91 cm Mrs E. Stacy

DEATH OF THE MOON-WOMAN

According to Aboriginal mythology, in most parts of Australia the sun is a woman and the moon is a man. But in the area of the Murray Mouth, on the great curved sweep of coastline known as Encounter Bay, the tribal myths described both sun and moon as being female.

The earliest recording of this belief came from the Rev. H. E. A. Meyer. In a pamphlet published in 1846 he wrote: 'The sun is considered to be a female who, when she sets, passes the dwelling places of the dead. As she approaches, the men assemble and divide into two bodies, leaving a road to pass between them; they invite her to stay with them, which she can do for only a short time, as she must be ready for her journey the next day. For favours granted to some one among them she receives a present of a red kangaroo skin, and therefore, when she rises in the morning, appears in a red dress.'

In Meyer's view, the moon was 'not particularly chaste, either, being of very light character'. The myth explains that the waxing and waning of the moon each month is brought about by the Moon-woman eating rich, fattening foods from the time of her first appearance as a thin sickle until the full of the moon.

Each time she sets, the Moon-woman joins the tribes on earth. Her intense nightly association with the tribesmen causes her to become thinner and thinner, until she wastes away and dies. After three moonless nights, a new moon is born and the cycle begins all over again, with the new Moon-woman searching for rich foods to build up her body.

91 x 122 cm Mr and Mrs Charles E. Hulley

THE FIRST BIRTH

Long before the dawn of time, the earth was uninhabited. There was no light, no living creature, not even a blade of grass to disturb that dim, featureless immensity.

Then, at some time during the period of darkness, an old blind woman, Mudungkala, rose out of the ground somewhere on south-east Melville Island. She clasped in her arms three infants: two girls, Wuriupranala and Murupiangkala, and a boy, Purukupali.

She had come to create the land of the Tiwis.

Carrying her children, she crawled along the land, in the process forming all the watercourses. When she had finished she disappeared. But before she left, she decreed that the bare land she had created should be clothed with vegetation and populated with creatures so that her children, whom she was leaving behind, and the generations to come, should have ample food and shelter.

And so her two daughters and son established themselves in the new land. Purukupali visited the homes of the spirit-children and brought some of them back to his sisters so that they could become mothers. Thus Mudungkala's family multiplied.

The creation of the peoples of the world had begun.

91 x 68 cm Mr Samuel and Mrs Wendy Olenick

III

BLACK PELICANS AND THE OUTCAST

In the long-distant past, Boora the pelican, in his sleek black plumage (all pelicans were black in those days), owned a bark canoe. Boora did not really need a canoe, for he could swim from place to place just as easily as he could paddle, but it pleased him to know that he possessed something the other birds did not.

One day, after a heavy storm had flooded the country, Boora saw, on a mud island in the middle of a turbulent river, a man and three women sitting on a stranded log. After many entreaties Boora agreed to rescue the Aborigines, but, being attracted by the youngest and prettiest girl, Kantiki, he secretly planned to steal her.

So, one by one the pelican ferried the Aborigines across, leaving Kantiki until last. But when Boora left with his third passenger, Kantiki, terrified at his obvious intentions, took the skin rug from her shoulders and, wrapping it around a log about the same size as herself, laid it on the sodden ground and slipped quietly into the water, hoping to reach her companions on the distant bank.

When Boora, full of expectation, returned to collect his prize, he was so angry at finding the girl asleep that he kicked the figure with all his might, severely injuring his foot. Furious over the loss of Kantiki, at the pain in his foot, and at being made to look ridiculous, he paddled back to his camp. Splashing white paint over his head and body, in the same way as the Aborigines did when about to take part in a fight, Boora was on the point of setting out to recapture Kantiki when the older pelicans saw his painted body.

They were so disgusted with his appearance that, attacking Boora with their long beaks, they drove him from the camp, decreeing at the same time that pelicans must never change their colour.

Yet in spite of this, so many of the younger birds, tiring of their sombre plumage, painted themselves with white that today all the pelicans seen on the shores of the lakes, or feeding in the billabongs, are black and white, as Boora was so long ago.

71 x 96 cm Mr Rhys Roberts

THE GUARDIAN OF OWL ROCK

Three hundred kilometres north-west of Alice Springs is Owl Rock, in Pulkakurinya Gorge. It stands guard over the only permanent waterhole in this remote area.

In the Dreamtime days of the Aborigines of Central Australia, Buk-Buk the owl and his two wives came to this spot in search of water. Drought had driven them from the Bigili rockhole to the north.

Determined never to be forced to search for water again, Buk-Buk has ever since stood guard over this waterhole—which has never been known to dry up. And there at its entrance today looms Owl Rock, testimony to that guardianship.

This unique and unexplained wedge-like stone rises to a height of more than ten metres, and although it is up to four metres thick, it balances on a base barely a metre in diameter. Its vertical strata stand out in marked contrast to the horizontal layering of all the surrounding hills—an everlasting puzzle to geologists, anthropologists and the Aborigines alike.

91 x 107 cm Mr and Mrs Charles E. Hulley

115

DINGO AND THE LAW-BREAKER

A long time ago, when the two dingo-men Munbun and Kapiri were on a desert journey, they became very thirsty. So they started to dig for water at Nirgo. Munbun, the younger, spent many hours making a long burrow towards the north, but without success; Kapiri, however, working in the opposite direction, discovered a spring of clear water.

While the dingo-men were resting, two medicine-men came along. Naturally the dingo-men invited them to drink at the newly dug spring, and then told them that as Nirgo was the only spring in the desert, they would give it to the Aborigines. The medicine-men were very impressed by this generosity, and made a new law that, for ever afterwards, Aboriginal hunters could kill only the father dingoes, never the mothers or the pups.

This decree was obeyed for a long time, until a selfish Aborigine killed and ate two dingo pups. When the culprit heard the mother dingo calling for vengeance, he knew that his only chance of escaping death was to get off the ground. He climbed a tree and sat on a high branch.

But the mother persuaded other dingoes to uproot the tree. Working slowly and surely, they dug away at its roots until, with the terrified Aborigine still clinging to its branches, it fell with a mighty crash. The offender's body was broken into many pieces, but the dingo pups were miraculously restored to their mother.

There is now a large hole in the ground where the tree once stood, with many red boulders scattered around it. They represent the congealed blood of the Aborigine who so foolishly broke the law of the medicine-men.

91 x 68 cm Mr James S. Anderson

WYUNGARE AND THE AVENGING FIRE

Wyungare, who lived on the shores of Lake Alexandrina, was a famous hunter, and so handsome that the two wives of Nepele fell in love with him.

They made an opportunity to visit his camp, and found him asleep. So they imitated the sound of running emus, and Wyungare awoke. He grabbed his spears and rushed to kill the birds; but instead of emus he saw the two women. They begged him to keep them in his camp—to which he readily agreed.

When Nepele heard what his wives had done, he was so angry that he hurried to Wyungare's camp to avenge the insult. When he found that all three had gone hunting, he punished them by laying a magic fire just outside their shelter. He commanded it to burst into flame when the culprits were asleep and, if they escaped, to follow them.

The magic fire obeyed his command, and pursued the hunter and the two women as they fled along the shores of Lake Alexandrina. At last, in desperation, they immersed themselves in the muddy water of the Lowangari swamp, and the fire drowned itself in its efforts to reach them.

Wyungare then decided that the only way to escape the hate of Nepele was to live among the stars. So he tied a rope to a barbed spear and threw it up into the sky, where it became firmly fixed. Wyungare and the two women then climbed to the stars, where they have lived ever since.

The myth also relates how Wyungare, when he lived on earth, once caught a giant kangaroo and tore it into pieces. He scattered them throughout the land, and from these fragments grew all the diverse members of the kangaroo family.

107 x 157 cm *Private collection*

HERITAGE OF THE BLACK SWANS

A group of women, the Wibalu, owned the only boomerangs in the world. The men of the surrounding tribes had often planned to take the weapons by force, but since the Wibalu used many powerful death chants to protect themselves, the men decided to acquire the boomerangs by guile.

So two of the tribe changed themselves into white swans, and flew to a waterhole near the women's camp. The men felt sure that when the swans flew overhead, the Wibalu, forgetting about their boomerangs, would rush away to gaze at the strange birds.

The scheme worked perfectly. As soon as the camp was empty, the men, who had been hiding nearby, seized the boomerangs and ran. The women, screaming with rage, rushed back to punish the thieves, but they had gone. The women then returned to attack the swans.

To escape the Wibalu, the swans flew to a lily-covered lagoon belonging to the eagles, who attacked the swans, tearing out their feathers. The eagles carried them to the desert, where they left them to die.

But a flock of crows, also enemies of the eagles, plucked feathers from their bodies to clothe the two swans, whose feathers today are therefore black. The swans' own white feathers became the dainty flannel flowers of the eastern Australian coast, and their blood was transformed into the blossoms of the scarlet heath.

68 x 91 cm Mrs B.L. Brennan

BIRTH OF AN ICE-MAIDEN

Most Aboriginal tribes have myths about the Pleiades, or, as we also call them, the Seven Sisters. Some tribes believe that these stars are a flock of kangaroos, being eternally pursued by the dogs of the constellation Orion; other tribes look upon them as a number of gumtrees, under which the spirits of the dead shelter when travelling to their eternal home; and others believe them to be a family of young girls.

To the Aborigines of north-eastern South Australia, the Seven Sisters, the Makara, are remarkable for their beauty. Their long flaxen hair reaches down to their waists, and their bodies are covered with glistening icicles. These Makara, the wives of the men of Orion, disappear over the western horizon about an hour before the men. This gives them time to make a camp, and to light a fire on which their husbands will cook the game they have speared in the course of their daily journey across the sky.

During late winter, when the Makara first appear in the eastern sky, the icicles falling from their bodies cover the earth with a layer of frost. It is at these times that the older boys and girls go to the nearest spring and rub the frost over their naked bodies.

This ritual makes the boys grow into strong and successful hunters, and the girls into beautiful women with large breasts. But they have to be extremely careful at these times, for should a beam of sunlight strike their bodies when covered with frost, they will always be weak.

68 x 102 cm *Miss Marcella Reale*

THE FIRST FIRE

There is considerable diversity in the Aboriginal myths dealing with the origin of fire. Some tribes believe that it originated in a lightning-flash, others that it came from a burning mountain, or that it was accidentally discovered by man. A myth of the Aboriginal people who lived on the north-western coasts of Australia tells how their fire came from the sky.

Two brothers named Kanbi and Jitabidi lived in the heavens. Their camp was near the Southern Cross, and their fires were the two Pointers, Alpha and Beta Centauri. At that time there was no other fire in the universe.

Food was getting scarce in the sky-world, so Kanbi and Jitabidi came to earth, bringing their firesticks with them. They established their camp, and laid their firesticks on the ground while they went out to hunt possums.

The two hunters were away so long that the firesticks, growing bored, began to chase each other about in the grass and among the branches of the trees. This game started a bushfire that burnt out much of the surrounding country. Seeing the smoke and the flames, the brothers returned at once to their earthly camp, recaptured the playful firesticks, and restored them to their place in the sky.

It happened that a group of Aboriginal hunters saw the fire and felt its warmth. Realizing the value of this strange new element, they took a blazing log back to their own camp, and from it many other fires were lit. Now all Aborigines have the fire that once belonged only to the men of the Southern Cross.

71 x 122 cm Mr V.G. Pike

THE FIRE TREE

The discovery of how to make fire not only altered man's way of life, but set him apart from the rest of creation as nothing else could have done.

A South Australian myth relates how a man, Kondole, hid his firestick rather than bring it with him to provide light for an evening's ceremony. When Kondole became a whale, another man, Tudrun, set out to find the precious firestick. He had not searched for long when he saw a grass-tree glowing with a strange light. This was Kondole's fire, which, escaping from its secret hiding-place, had set alight the dry flower stem of the grass-tree.

Ever since, when the Aborigines need fire, they take a flower stem of the grass-tree and rub it vigorously with a piece of harder wood. The friction causes Kondole's hidden fire to ignite the powdered wood-dust, and the Aborigines have fire; fire to cook their food, fire to keep them warm, and fire to protect them from the dangerous spirits of the night.

68 x 91 cm Mr and Mrs Feres Trabilsie

JARAPA AND THE MAN OF WOOD

Jarapa, a man of the Waddaman tribe in the long-distant past, fancied himself as a magician and tried to create a human being. He cut a piece of wood from a tree, shaped it to look like the body of a man, and added sticks for the arms and legs, and rounded stones for the knee and arm joints. All day and night Jarapa beat his tap-sticks and sang a secret song over the image until his voice became hoarse, but the object did not respond. At last Jarapa gave up in disgust and walked away.

But he had not gone far when he heard the crashing of trees behind him, and he saw that the man of wood, grown hugely, had come to life and was following him. A white cockatoo clung to the monster and screeched warnings to all creatures in its path.

Terrified, Jarapa could not escape the man of wood—until he realized that it was pursuing him by sight only: it became confused when Jarapa was out of sight. So he hid behind a large rock, and his creation blundered past and at last disappeared over the horizon.

For countless generations of Aborigines, the spirit of Jarapa's man of wood was known as the Wulgaru, the self-appointed judge of the dead. Some believe that it still wanders around northern Australia in search of its creator.

68 x 91 cm Mr B. Consiglio

SONGMAN AND THE TWO SUNS

During the remote past, Junkgao, a mythical creator, his wife Walo the Sun-woman, her daughter Bara and his sister Madalait lived in a country far to the east of Arnhem Land.

One day, Junkgao and his sister Madalait set out in their bark canoe to cross the sea to Arnhem Land. As they neared their destination, they enjoyed the beauty of the long white sandhills on the distant shore and the lines of light that were reflected from the crests of the oncoming waves.

At the same time, Walo the Sun-woman and her daughter Bara rose in the east to make their daily journey across the sky. But Walo sent her daughter back, being afraid that the heat of two suns in the sky at one time would not only scorch the hair of the Aborigines, but might even set the whole world on fire.

This early-morning spectacle so pleased Junkgao that he composed many songs on the beauties about him: the sunrise, the light on the crests of the waves, the sound of the waves breaking on the beach, and the parallel lines of white sandhills.

At the same time, Junkgao decreed that the lines of light on the waves, and those of the sandhills, should be his and his descendants' sacred marks forever.

68 x 91 cm *Private collection*

131

THE CALL OF TUKIMBINI

On Melville Island, at the close of the creation period, it was the man, Tukimbini, who instructed the mythical people how to create the Aborigines' foods, and how to change themselves into the animals, birds, fish and reptiles now belonging to the locality.

But first, Tukimbini taught them the rules of behaviour one to another; and, so that there would be peace in the tribe, the laws of marriage and of social relationships. Tukimbini also laid down the periods of light and darkness that determine the daily cycle.

When the first light of the Sun-woman's torch shows in the eastern sky, it is the soft call of Tukimbini, now the yellow-faced honey-eater, which awakens the Aborigines. The men go out hunting, and the women gather the vegetable foods from the forests and the swamps.

At noon, when the Sun-woman makes the day uncomfortably hot by cooking the food she has gathered during the morning, the Aborigines seek the shade of the jungle and remain there until the day is cooler. They then continue their food-gathering, returning to cook and eat their evening meal as the torch of the Sun-woman sinks behind the western horizon.

Soon, darkness moves across the sky, the stars begin to show, and the twinkling fires of the men of the Milky Way span the heavens. In a short time the Aborigines are asleep. Next morning they will again be wakened by Tukimbini, his melodious call heralding yet another day.

68 x 91 cm Mrs Melva Roberts

THE SPIRIT DINGO OF AYERS ROCK

At one time, when the hare-wallabies at Ayers Rock were initiating their youths, they received an invitation from the mulga-seed people of Kikingura, a mountain far away to the west, to attend one of their ceremonies, and to bring with them a parcel of eagle-down for body decorations. The hare-wallabies, annoyed by such an invitation when they were busy with their own rituals, sent a curt refusal. Instead of the eagle-down, they sent a parcel of white ash.

This insult made the mulga-seed tribesmen so angry that they decided to create a powerful spirit dingo, Kulpunya, who would kill all the people at Ayers Rock. So the spirit dingo was made with a mulga branch for a backbone, forked sticks for ears, the teeth of a marsupial mole and the tail of a bandicoot. But it was only after several days of secret rituals and the chanting of many lethal and malevolent songs, that the medicine-men were able to bring Kulpunya to life with sufficient hatred and venom to carry out his task.

Meanwhile, the Ayers Rock people, not suspecting danger, were following their normal way of life. But an old kingfisher-woman, Lunba, expecting an attack from the mulga-seed people, had built her camp high up on the rock so that she could watch for approaching enemies.

At about midday, when everyone else was asleep, Lunba saw Kulpunya in the distance. But although she raised the alarm, the spirit dingo destroyed most of the hare-wallabies before they were fully awake. There were, however, a number of initiates and their guardians who, on hearing Lunba's warning, fled to the east and escaped.

76 x 102 cm *Mr Rhys Roberts*

THE FIGHTING BROTHERS

Long ago, on Victoria's western coast, there lived two brothers who had hunted and fished together since childhood. Pupadi, the elder, was the one who always speared the most game, knew the best fishing spots, and was looked upon as the camp favourite. Gerdang, the younger, secretly resented his secondary role. His jealousy increased when Pupadi took a wife, because she was the woman Gerdang most desired.

Gerdang's longing for his brother's wife became so fierce that he begged her to run away with him. When she refused, Gerdang took her by force and carried her far to the east, where a great shelf of rock runs into the sea.

Pupadi returned from hunting, and realized what had taken place because he was aware of Gerdang's envy. In a violent rage he followed their tracks and found his wife and brother. He attacked Gerdang, and they fought for many hours until the younger brother ran into the scrub and hid. Pupadi climbed a large rock to gain a better view, but Gerdang circled behind him and threw a boomerang with such force that it buried itself deep between his brother's shoulder-blades and knocked him into the bushes at the cliff's edge.

Reckless with triumph, and expecting to find his brother dead, Gerdang leapt into the bushes. But Pupadi, calling on the last of his strength, lay on his stomach with his spear held upwards. Gerdang jumped straight on to it, to die with the barbed point sticking out through his back.

The impact carried them over the cliff, and Pupadi fell into the sea and became the shark. The big fin on his back is his brother's boomerang, still deeply embedded. Gerdang hit a shelf of rock with such force that his body was flattened, and in this form the tide carried it away as the stingray, with Pupadi's spear changed into the barbed sting at the base of the tail. The blowholes along the clifftop were made by the stamping feet of the fighting brothers.

91 x 122 cm Private collection

THE DROUGHT-MAKER

The Aborigines believe that if the body of a dead koala is not treated properly, its spirit will cause the rivers to dry up, and everyone will die of thirst. A myth from south-eastern Australia tells how this belief originated.

An orphaned koala-boy, Koobor, was constantly ill-treated and neglected by his relatives. Although he had learnt to live on the foliage of the gumtrees, he was never given sufficient water to quench his thirst.

One morning, when his relatives set out to gather food, they forgot to hide their water-buckets, so that for once in his life Koobor had enough to drink. But, realizing that unless he stored some water for himself he would soon be thirsty again, the boy, collecting all the buckets, hung them on a low sapling. Then, climbing into the branches, he chanted a special song that caused the tree to grow so rapidly that it was soon the tallest in the forest.

When the people returned in the evening, tired and thirsty, they were indignant to see the water-buckets hanging at the top of a very high tree, with Koobor sitting in the midst of them. The men demanded that Koobor return the stolen water, but he replied that, as he now had all the water, it was their turn to go thirsty. After a number of attempts had been made to climb the tree, two clever medicine-men succeeded, and, harshly beating him, threw the little thief to the ground.

As the people watched, they saw the shattered body of Koobor change into a koala, climb into a nearby tree, and sit in the top branches, where today he does not need water to keep him alive. Koobor then made a law that, though the Aborigines may kill him for food, they must not remove his skin or break his bones until he is cooked. Should anyone disobey, the spirit of the dead koala will cause such a severe drought that everyone except the koalas will die.

91 x 122 cm Mr and Mrs David H. Brown

WUNGALA AND THE EVIL-BIG-EYED-ONE

Wungala was away from the camp with her small son, Bulla, and all morning they had gathered seeds. Afterwards, she sat at her milling-stone and ground the seeds into powder, then added water to make it into a thick dough. Bulla ran around, laughing and talking to himself as he gathered sticks to put on their fire.

The sun shone brightly at first, but when some clouds threw a shadow across the earth, Wungala called her son to her and told him to stay close, warning him that he must now remain quiet. When Bulla asked why, his mother explained that with the shadows came the Evil-Big-Eyed-One from his cave in the hills, and should it hear Bulla's chattering, it would seek him out and eat them both up.

Bulla, being very small and forgetful, wandered off again, only to rush back to his mother screaming that he had seen the evil one. Wungala, too, had seen it coming their way, and she said, 'You are wrong, Bulla, nothing is there but the shadows made by some waving bushes.'

She spoke as calmly as she could, knowing that they were safe only if she pretended that the evil one was not there. If they showed panic, and ran, they would be finished. So she went on talking calmly, making more and more dough, and finally putting it on the hot coals to bake.

Each time the Evil-Big-Eyed-One came closer, and roared at them, Bulla cried out in fear. And each time, Wungala calmed Bulla by telling him that the noise was only a wallaby, or a cockatoo, or some other creature out there in the bushes.

The evil creature was puzzled by this show of indifference, and wondered why it should seem to be invisible to the woman. In its curiosity, it crept right up behind her. This was the moment when Wungala carried out her desperate plan. She gathered up the great mass of dough in both hands, swung around, and threw the hot sticky mass in its face.

Quickly picking up her son, Wungala fled back to the camp and the safety of her people, leaving the evil one roaring in agony as it tried to scrape the hot dough from its eye and mouth.

68 x 91 cm Mr Fraser Hay

WULUWAIT, BOATMAN OF THE DEAD

When the long mourning rituals of the Aborigines of Arnhem Land are completed, and the bones of the dead person are at last interred in the log coffin, his spirit—or the Mokoi, as it is called—leaves his place of burial and, entering a bark canoe, is paddled by the ghostly boatman, Wuluwait, to the island of Purelko, the Aboriginal 'heaven'.

The journey takes many days, for Purelko lies far beyond the rising of the sun and the morning star: during the journey many dolphins swim beside the canoe to guide it to its destination.

When the canoe nears the shores of Purelko, a masked plover, who has been watching the progress of the canoe, rises into the air with a shrill call to tell the spirits that Wuluwait and his companion, the Mokoi, have arrived.

The leader of the Aboriginal heaven welcomes the new spirit; but before he can take any part in the community life of Purelko, the Mokoi must submit to an ordeal in which the men of Purelko cast spears into his body until his skin becomes hard, and impervious to wounds. This ordeal transforms the new spirit into a young healthy person of cheerful temperament, for in Purelko there must be universal happiness and goodwill.

68 x 91 cm Mr F.E. Cork

ACKNOWLEDGEMENTS

A number of the myths in this volume are printed for the first time. Others have appeared in numerous versions over the past 140 years and every effort has been made to discover their origins. The fact that different tribes used variations of some basic myths, and that early European writers interpreted these in many different styles and ways, has made it difficult to ascertain the dates and authors of the first versions to be published in English. The sources listed are the earliest that can be traced, and we thank those who have granted permission to use such sources as reference. In some cases it has not been possible to trace either the author or the publisher of the original material. The debt to the Australian Aborigines, who originated and perpetuated these myths of their Dreamtime, is most gratefully acknowledged.

SOURCES

Australian Inland Mission Frontier Services. *The Storyteller*. 1976.
Brewster, Mrs Edna. Adelaide, 1974.
Harney, W.E. *Life among the Aborigines*. Robert Hale, London, 1957.
Harney, W.E. *Tales from the Aborigines*. Robert Hale, London, 1959.
Lockwood, Douglas. *Northern Territory Sketchbook*. Rigby, Adelaide, 1968.
McKeown, Keith C. *Land of the Byamee*. Randle House, Sydney, 1938.
Mathews, R.H. *Mythology of the Gundungurra*. Folk-Lore Society, London, 1909.
Peck, C.W. *Australian Legends*. Stafford & Co., Sydney, 1925.
Poole, G.G. *Leigh Creek*. Adelaide, 1946.
Reed, A.W. *Aboriginal Fables*. A.H. & A.W. Reed, Sydney, 1965.
Robinson, Roland. *Aboriginal Myths and Legends*. Sun Books, Sydney, 1966.
Smith, W. Ramsay. *Myths and Legends of the Australian Aboriginals*. George G. Harrap, London, 1930.
Spencer, B. and Gillen, F.J. *The Northern Tribes of Central Australia*. Macmillan & Co. Ltd, London, 1904.
Taplin, Rev. George. *South Australian Aboriginal Folklore*. Adelaide, 1879.
Turner, R. *Australian Jungle Stories*. Northwood Press, Camperdown, Victoria, 1936.
Woods, J.D. (ed.). *The Native Tribes of South Australia*. E.S. Wigg & Son, Adelaide, 1879.

Dr CHARLES P. MOUNTFORD,
OBE, MA, D.Litt.(Adel.), Dip.Anthropol.(Cantab.), Hon.D.Litt.(Melb.).

The authors wish to record their appreciation to the memory of Dr Mountford, good friend and fellow wanderer, for his encouragement and patience; through his eyes the authors caught their own first glimpse of the magic and mystery of the age-old culture of the Australian Aborigines. The authors extend their thanks to Mrs Bessie I. Mountford, for her ready permission to use myth interpretations by her late husband.